Jean Painlevé

Foreword

This is the first solo exhibition in the UK of work by the pioneering French filmmaker Jean Painlevé (1902–1989), best known for his documentaries about marine creatures. Also a prolific writer and public speaker, in 1948 he proclaimed 'Ten Commandments' on the practice and theory of filmmaking, including five as follows:

> You will not make documentaries if you do not feel the subject.

> You will refuse to direct a film if your convictions are not expressed.

> You will abandon every special effect that is not justified.

> You will not show monotonous sequences without perfect justification.

> You will not substitute words for images in any way.

Painlevé's insistence on entertainment as well as education through moving imagery of sea horses, vampire bats, octopi, shrimps and hermit crabs, suggesting human traits — the erotic, the comical and the savage — was radical at the time and has since proved to be very influential.

Painlevé studied biology at the Sorbonne and at the age of 21 became the youngest researcher ever to present a paper (on colour staining of glandular cells in midge larvae) to the Académie des Sciences. Prior to this he had been a member of the French Union of Communist Students, the manifestation of a strong anarchist tendency that also put him in touch with the Surrealist movement and avant garde filmmakers such as Luis Buñuel and Sergei Eisenstein. He also became well acquainted with Man Ray and Alexander Calder.

In 1924, Painlevé published 'Neozoological Drama', a pseudo-scientific text describing interactions between sea creatures and in the following year made his first film, *L'œuf d'épinoche: de la fécondation à l'éclosion*, on the stickleback egg. His intense enthusiasm for his subject matter led him to invent all kinds of equipment for filming. In order to shoot scenes underwater, he encased his camera in a custom made waterproof box, fitted with a glass plate. In his 1935 essay, 'Feet In The Water', Painlevé described how he then went about getting the footage required: "Wading around in water up to your ankles or navel, day and night, in all kinds of weather, even in areas where one is sure to find nothing, digging about everywhere for algae or octopus, getting hypnotised by a sinister pond where everything seems to promise marvels although nothing lives there."

Painlevé's nature films tend to focus on single organisms, capturing crucial moments in their life cycles, and in doing so he often expressed his free thinking. Many of his subjects — such as the sea urchin and the acera, a tiny mollusc — would normally have been considered unworthy of attention, but it was their weirdness, the surreality of real life, that obviously appealed to him. Not soft and cute, not Disney-like, they embodied a challenge to conventional bourgeois values — with a courage born out of conviction as the artist himself had called for in his "commandments".

In this vein, the appearance of the seahorse early on in Painlevé's films signified a kind of ethical positioning. Specifically, he was concerned to draw attention to the way in which male and female seahorses share childbirth. The abdomen of the male has a pouch into which the female lays her eggs and once the eggs are fertilised, it is the male who nourishes them and, in time, gives birth in a way reminiscent of human labour. As Painlevé explained, "The sea horse was for me a splendid way of promoting the kindness and virtue of the father, while at the same time underlining the necessity of the mother. In other words, I wanted to re-establish the balance between male and female."

Such progressive gender politics are evident also in *Acera or The Witches' Dance* (1978). Much of the film is devoted to the ballet-like mating ritual of these tiny shellfish in which the cloaks that encircle their bodies fly open, as if they were tutus. After coupling occurs it is revealed that the acera are bisexual, functioning either as male or female, or simultaneously as male and female, and so Painlevé shows them having sex by fertilising the eggs of others while their own eggs are being fertilised.

Painlevé was especially taken with cinema's ability to transform microscopy into an experience that audiences could share, condensing and expanding duration in order to demystify processes of the natural world. A popular film of his that did not feature an animal species was *Phase Transition in Liquid Crystals* (1978) documenting how changes in pressure and temperature affect the appearance of liquid crystals.

There was a cross disciplinary zeitgeist that saw Painlevé working closely not only with visual artists — e.g. in his 1932 film of Calder's mobiles — but also with musicians. Without compromising the scientific dimension of his work, he felt quite free to work with sound and image in imaginative ways, and besides the use of recordings of both jazz and classical music (from Duke Ellington to Chopin and Scarlatti) as soundtracks, he commissioned composers to produce new work for his films, including pioneers of electronic music such as Pierre Henry and François de Roubaix.

Following the success of his seminal film of the seahorse, *L'hippocampe ou 'Cheval Marin'* (1934), in a somewhat unconventional and provocative move, Painlevé launched a range of jewellery. Made from gilded brass and decorated with Bakelite sections foiling little brass seahorses, it comprised various designs of bracelets, dress clips, earrings, brooches and necklaces and was retailed by chic boutiques and the department store Printemps in Paris. One of the early examples of film merchandising, it is displayed at Ikon as an introduction to the exhibition, in a room decorated with Painlevé's seahorse motif wallpaper, thus exemplifying his experimental nature, his unpreciousness, and impulse to communicate the wonder of his scientific and artistic pursuits.

We share this impulse strongly, especially with Marie Jager of the Archives Jean Painlevé (Paris) who initiated this project. She knew Jean Painlevé very well and is one of the few to have an extensive knowledge of his work and archives. Her essay herein is wonderfully informative. Also we take this opportunity to express our gratitude to colleagues Ian Francis, Franck Gautherot, Seungduk Kim and Stephan Meier, each of whom has contributed significantly to this outcome. How lucky we are that Jean Painlevé came before us.

Jonathan Watkins
Director

5

A Walk in the Forest
Jean Painlevé

The Sea Urchin is a delicacy. Gourmets
soak up everything by dipping a piece of
bread in the open shell; discerning palates
choose the reproductive glands: iodised
hazelnut. But the most amazing part is
the shell. At first glance, one sees only an
impenetrable forest, but then begins to
distinguish the moving spines. And with
greater scrutiny, it is revealed that these do
not aid locomotion at all, but that this role
is assured by a system of highly specialised
hydraulic feet: passing through hundreds
of holes in the shell are little flexible stems,
each ending in a sucker. Under the shell,
these hollow stems swell into a bulb, and
all the bulbs are connected to each other by
channels of water. When the bulbs contract
they force water into the elastic stems
which then extend forward, transforming
the forest into a flower. If the suckers
encounter an obstacle, they stick to it. The
stems then shorten, sending water back
into the bulbs, and the sea urchin is pulled
toward the fastened suckers.

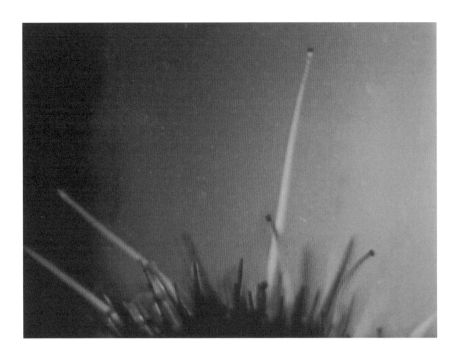

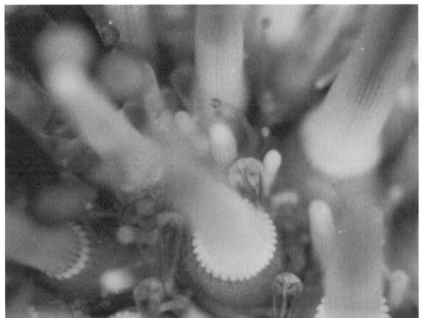

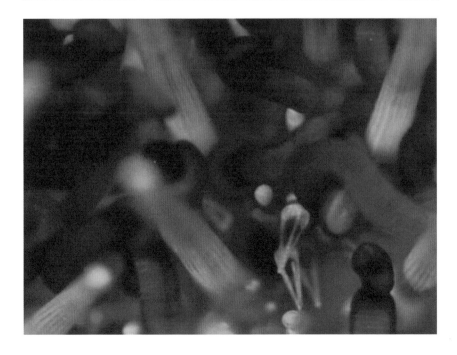

Sea Urchins, 1958

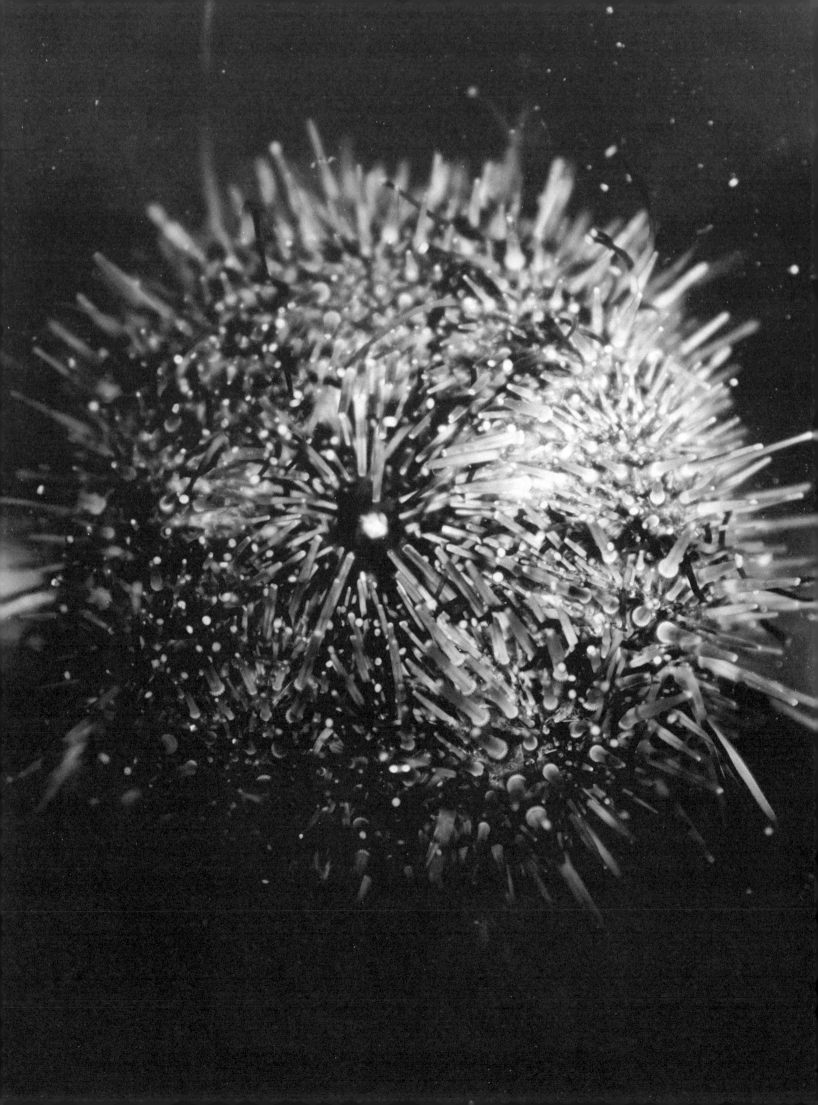

Magnification allows us to venture deeper into the forest. Around the spines, which now look like Doric columns, we discover another smaller forest of shrubs. These are the pedicellariae: minuscule organs belonging to the sea urchin and formed of the same substance as the spines. Their hard stems end with three jaws, which muscles open and close perpetually. Some pedicellariae have long, thin jaws with an openwork design. Others, powerful and continuous, evoke the heads of serpents. Others still, the cleaning pedicellariae, resemble clovers; they clean the surface of the sea urchin and the fluting of the spines. Lastly, some pedicellariae possess jaws equipped with poisonous glands and teeth bevelled like hypodermic needles. And over the entire sea urchin extends a carpet of vibratory cilia, except on the ends of its spines … Perhaps, these have been worn down …

Opposite:
Sea Urchin, 1927

Forms and Movements in the Documentary

Jean Painlevé

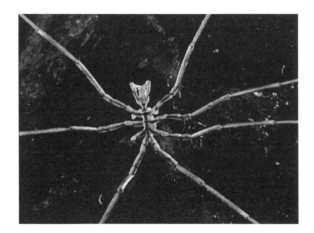

When cinema is inspired by the simplest, plainest of facts, sourced straight from Nature, there is always a quality of pure poetry and unmatched pictorial beauty to it that the vague colours of today's processes struggle to do justice to — hence we tend to remember only the form. Nonetheless, it must be noted that, however unsatisfactory and arbitrary the result, colour cinema is a good thing: a ladybird in colour looks better than a black and white one, even if its red is not the genuine red. And soon we will be able to render beautifully the delicate colour variations of an octopus, the iridescence of crystals when light is polarised, or the gentle withering of roses, filmed in fast motion.

But the form alone is delightful in itself, and if it is more readily noticed in plants and animals, it is just as true about inanimate objects. Things of physical and chemical nature are as harmonious or strange as anatomical structures and evolutions. Harmony, whether static or dynamic, does not rely solely on symmetry. In most cases anyway, some unique characteristic will enhance it. As for strangeness (the exotic being just one manifestation of it), it can be captured via a simple journey through the mundane thanks to unusual lighting or magnifying techniques. Even surreal results can be obtained without requiring the use of special technical means such as X-rays. (We will remember the radioscopic film in which the skeleton of a fiancée's head could be seen leaning over the skeleton of flowers.)

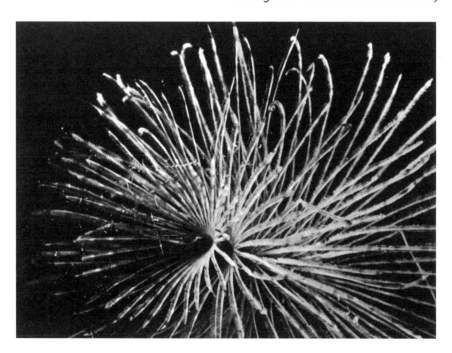

Whereas all you need to do with ordinary techniques is follow the action and focus the lens at the right time to get a moving document, with special techniques such as slow and fast motion, there is no way of knowing in advance what the result will be: this is true discovery. Along with the use of films of a different radiation sensitivity from the eye, these are the only methods where cinema is truly necessary as a research tool. These rhythm variations between the shooting and the showing of the film make for impressive dynamics on screen. The shooting of a welding process at a speed of 2,000 frames per second, played back at a standard speed of 24 frames per second, once showed how the projected material followed a parabola on the way back down to becoming melting material or escaped altogether along a hyperbola. The same phenomenon can be witnessed in Mr Bernard Lyot's film on the solar corona, although in this case the film was made in very slow motion and shown on screen at 200 times the speed: millimetres in the first shooting corresponding to hundreds of thousands of kilometres in the second shooting.

It is undeniable that movement, cinema's specificity, adds an astonishing grace or power to shapes. If a comatula — a type of starfish with very fluid arms — is certainly stunning when motionless, it looks all the more graceful when it is dancing on points. A sea urchin's unwelcoming spiny shell becomes majestic and threatening when magnified under a microscope. Its many prickles turn into Doric columns that lean at various angles and, amidst these collapsing temples, one can observe the movement of pedicellariae, snake-like organs that grow out of the urchin like our nails grow from our own substance. These tiny organs, which consist of an articulated stalk that grows out of shell outgrowths, with a head at its end, move endlessly. The heads comprise three jaws. Some have long slender mesh-like jaws, as delicate as lace; others have jaws that resemble clover leaves and clean the prickles' flutings; other urchins' jaws are powerful and abut around the mouth, taking the food to the animal's mouth; while other urchins have jaws equipped with venom glands and tipped with injecting claws, a means of defence.

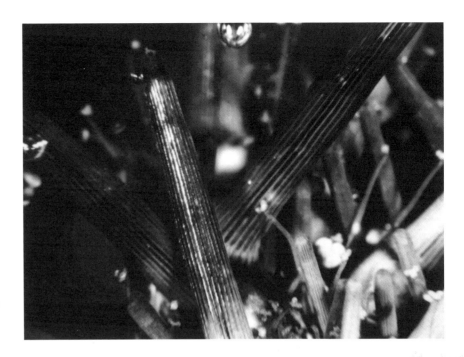

For inanimate objects, movement can be created by moving the camera itself. These altered and unexpected volumes, studied and constructed as if they resulted from the cross-section of a three-dimensional solid made by another solid, can be explored through the camera lens. And what a marvellous journey around this volume … Luciano Emer made such a film to examine Bosch's painting *Paradise Lost*. In a film on radars, we have witnessed the ghostly wandering of the signals caught on the electronic tube screen by cinematography.

And mushroom killings … This is not about poisoning — a commonplace — but about the film made by Doctor Comandon where one can see tiny worms lassoed and strangled by the root collar formed by mushroom strands that eventually thrust real choke pears at them to suck them up. What about this absolute genius of a process: cell division, with its endlessly similar protocol, the initial expulsion of half the chromosomes; half in number in the first instance, then half in volume in the second division? The film, made in slow motion and projected on screen in fast motion, shows the unforgettable moves of a fully "pregnant" world, of explosive forces building momentum before the release of the two little parent balls that will form the cells and where, following their still mysterious process, chromosomes will organise themselves to form new cores. In the space of a second, with an unimaginable amount of cells, such a number as would be necessary if we were to write in centimetres the distance between stars, the immutable operation starts. This protocol is not always adhered to, however … Anarchic cells occasionally only split their core in two, with no problem at all, and do not split; they simply grow with more and more cores. In fast motion, cancerous cells look like they are flapping their wings like seagulls.

Whether simple or complex, lines and rhythms are recorded like a vision of eternity. One of the missions of cinema is to give mankind this glimpse of Nature's most inescapable, cosmic aspects.

Spines of the Urchin Greatly Enlarged, 1927

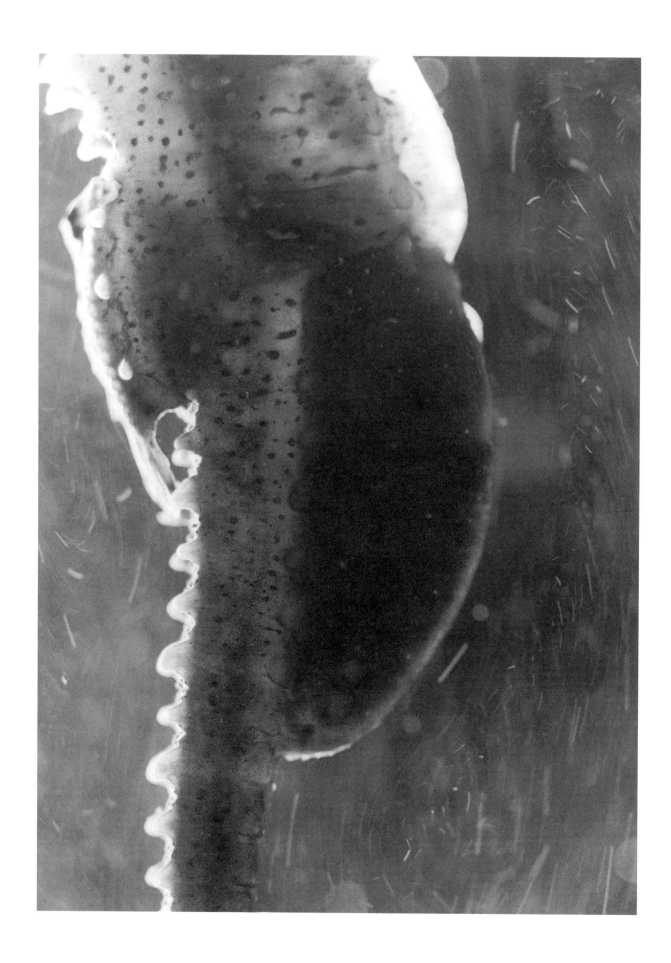

12 *Stomach of the Seahorse*, 1931

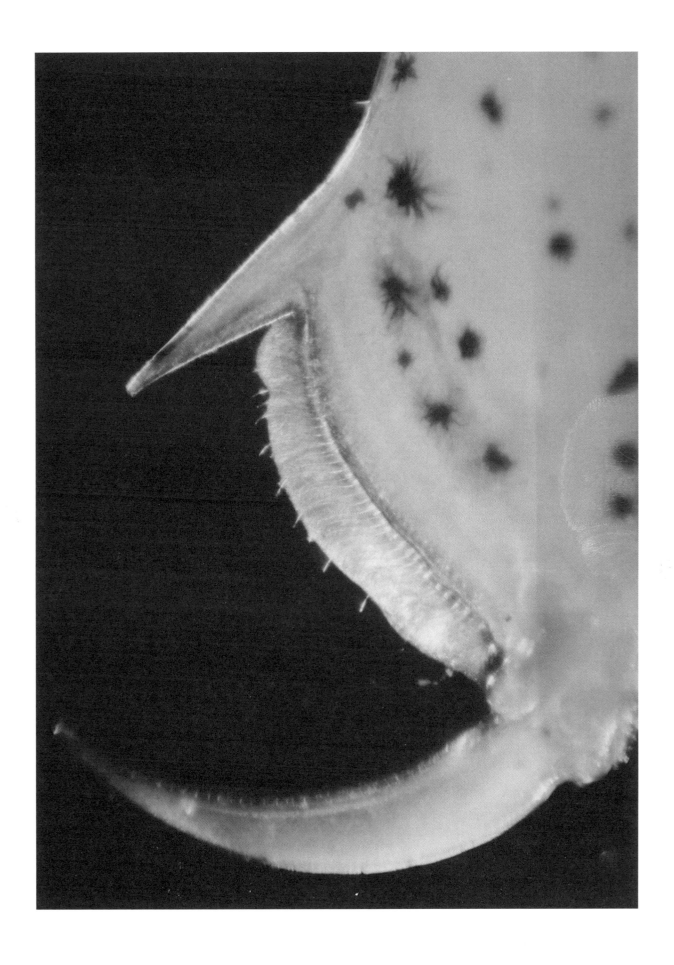

Shrimp Claw, 1929

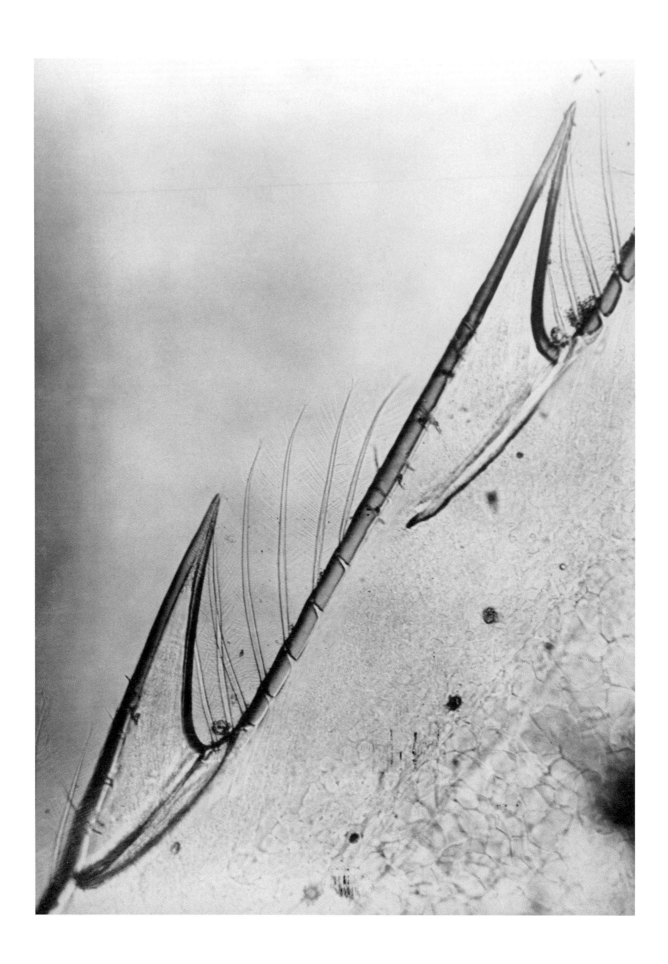

Rostrum on the Nose of the Shrimp, 1929

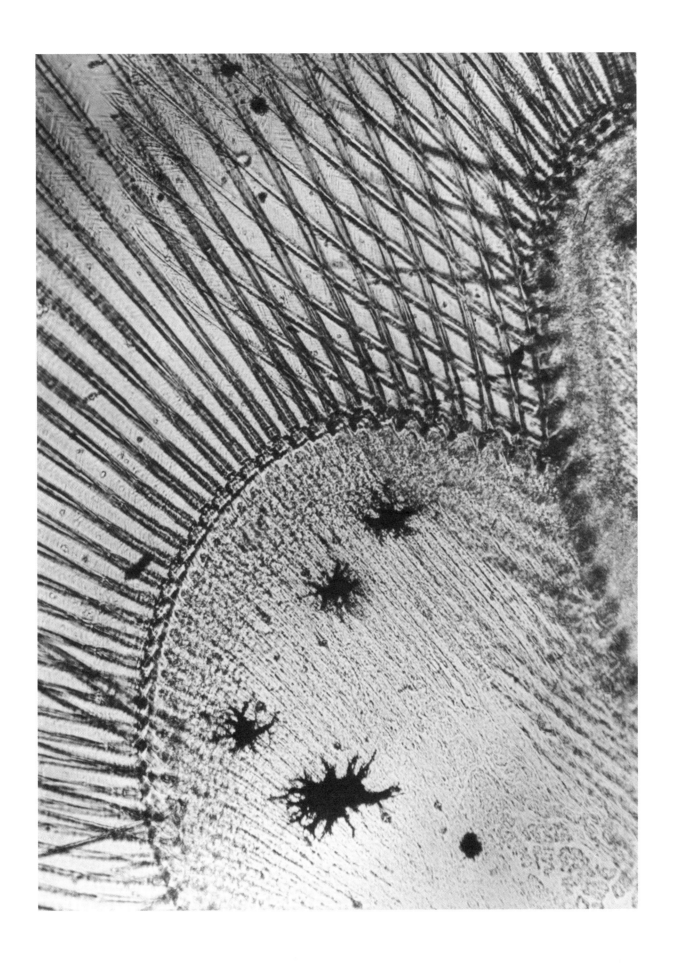

Shrimp Tail Greatly Enlarged, 1929

Astonishment
Jean Painlevé

The Periophtalmidae perch themselves
on bushes and retract their eyes into their
skull, sniffing. Other equally rare fish carry
their eyes at the end of an extendable stem:
it is as practical as it is attractive. But most
can only gyrate their ocular globes in their
sockets, often independent of each other.

Without eyelids or folds, the round eyes
of the fish express permanent astonishment.
Yet such an air of surprise is justified
upon meeting sea horses and their slow
moving circular figures, incapable as they
are of fleeing; but flight would hardly be
permitted, given their dignified stance.

And what shall the other fish say of these
vertical brethren, with their dignified
sadness, imprint of ancient gargoyles?

Opposite:
Horns of the Seahorse, 1931

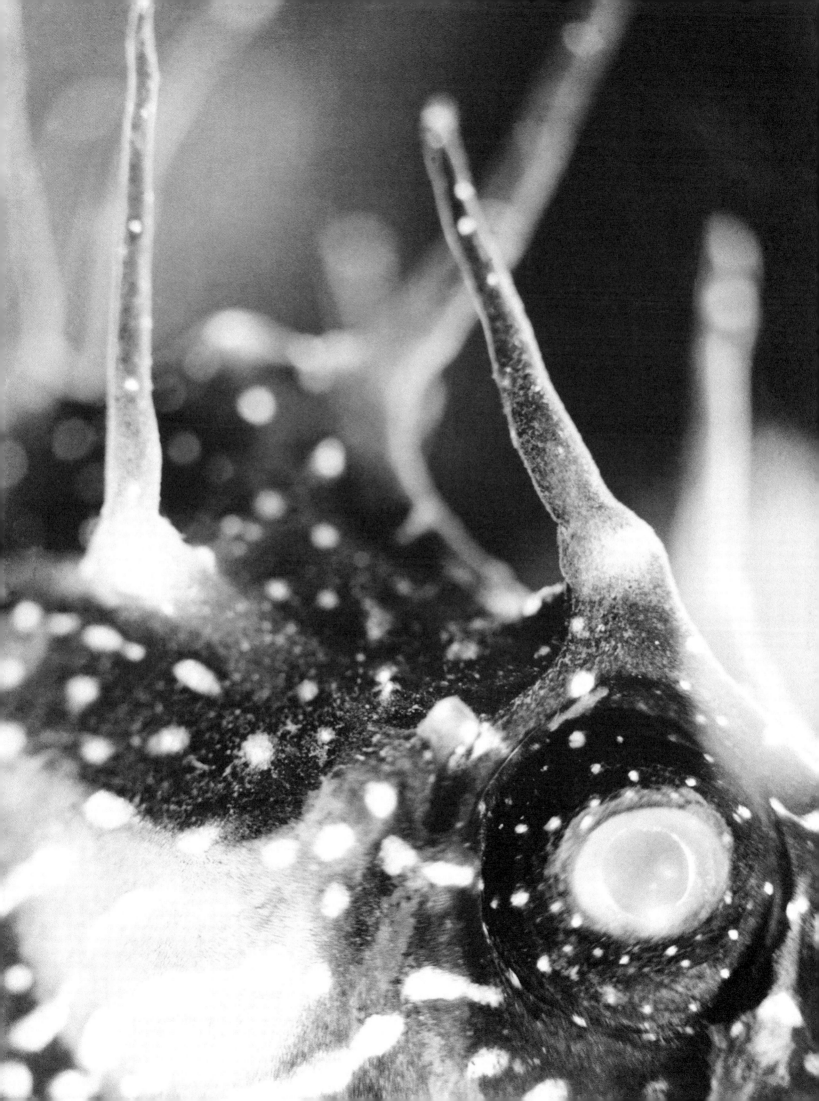

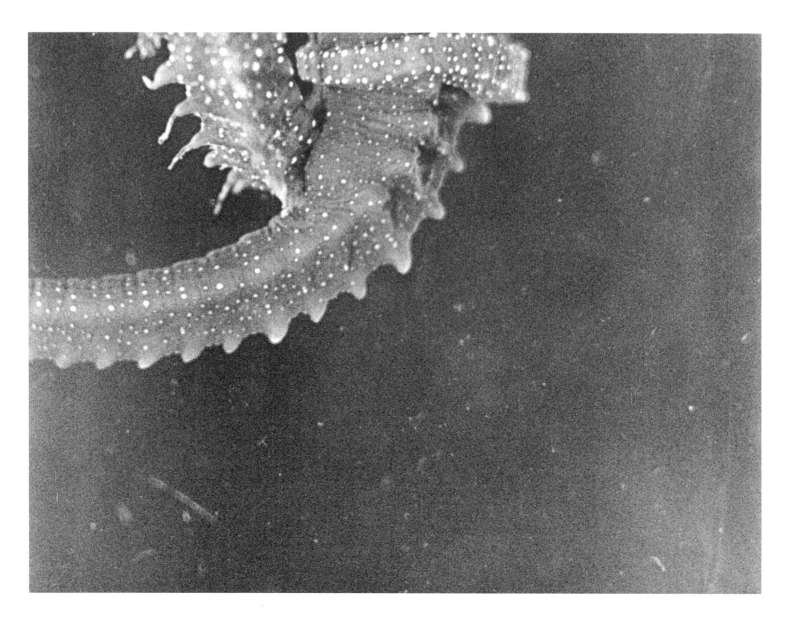

And what about their moral standards! Not only does the female take the male by thrusting her cloacal sac into the pouch of the latter's stomach, but she also transfers her two hundred eggs to him. The male then fertilises them, after which he carries them for several weeks: a genuine placenta is formed that makes the father's blood participate in nourishing the embryos. This is followed by a painful delivery rich in suffering and agonising labour.

If only all ended there! But the damned secretion of gases continues in the pouch after the last-born has been expelled. Sometimes the lips of the orifice get stuck together; the pouch swells up and leaves the male floating with his head upside down, which is no enviable position.

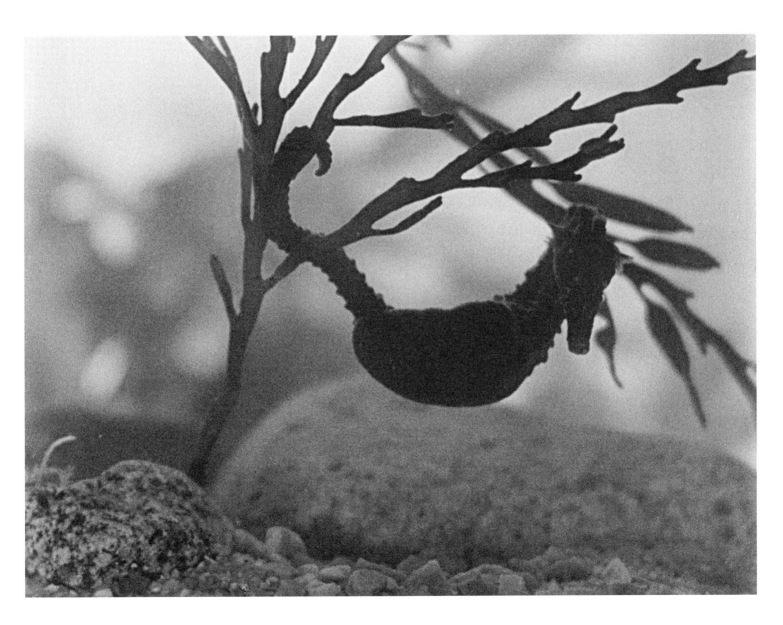

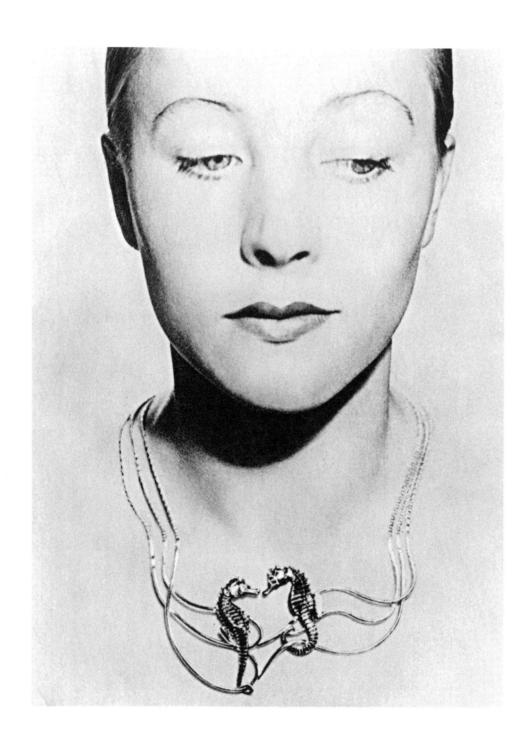

Advertising photograph for jHp jewellery, c. 1936
Photograph by Philippe Halsman

Opposite:
jHp necklace, c. 1936
jHp earrings, c. 1936

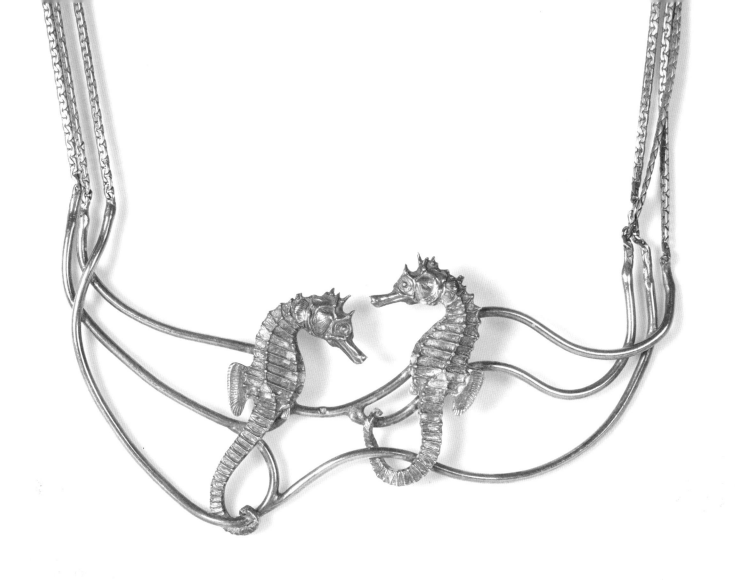

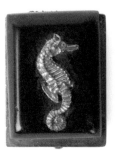
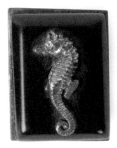

jHp Seahorse Motif n° 7, c. 1936
Design by Geneviève Hamon

Opposite:
jHp bracelet cuff, c. 1936
jHp brooch, c. 1936
jHp bracelet, c. 1936

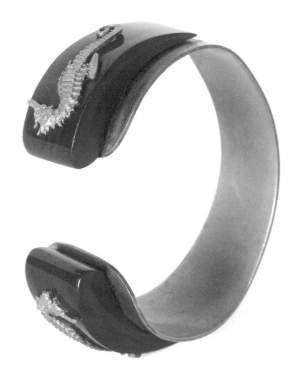

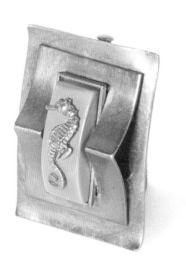

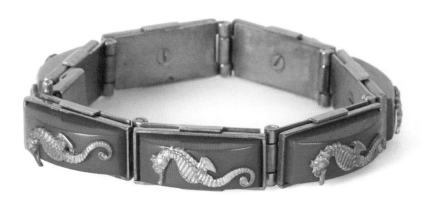

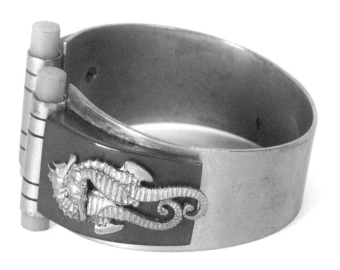

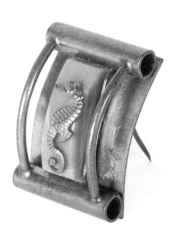

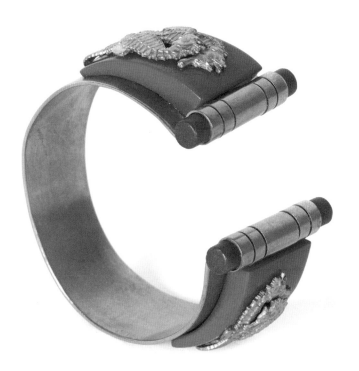

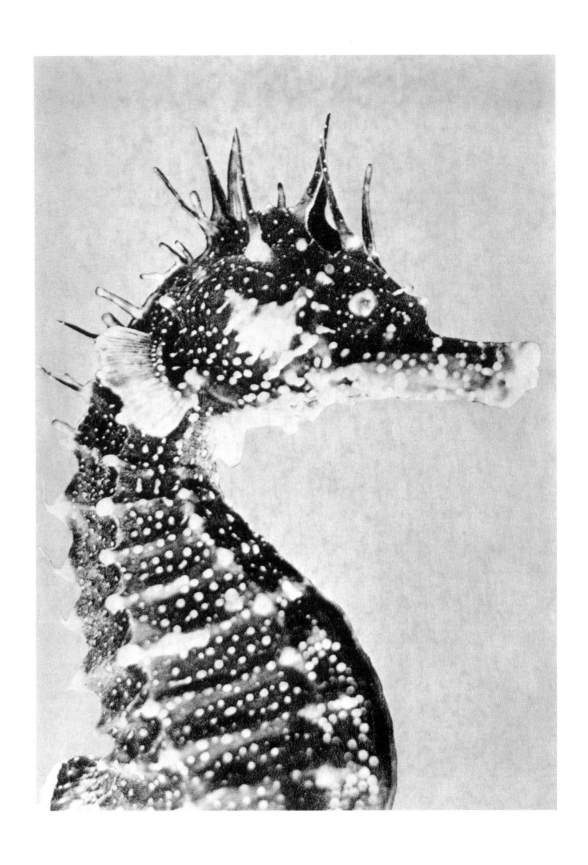

Opposite:
jHp bracelet cuff, c. 1936
jHp brooch, c. 1936
jHp bracelet cuff, c. 1936

Solarised Seahorse Torso, 1931 25

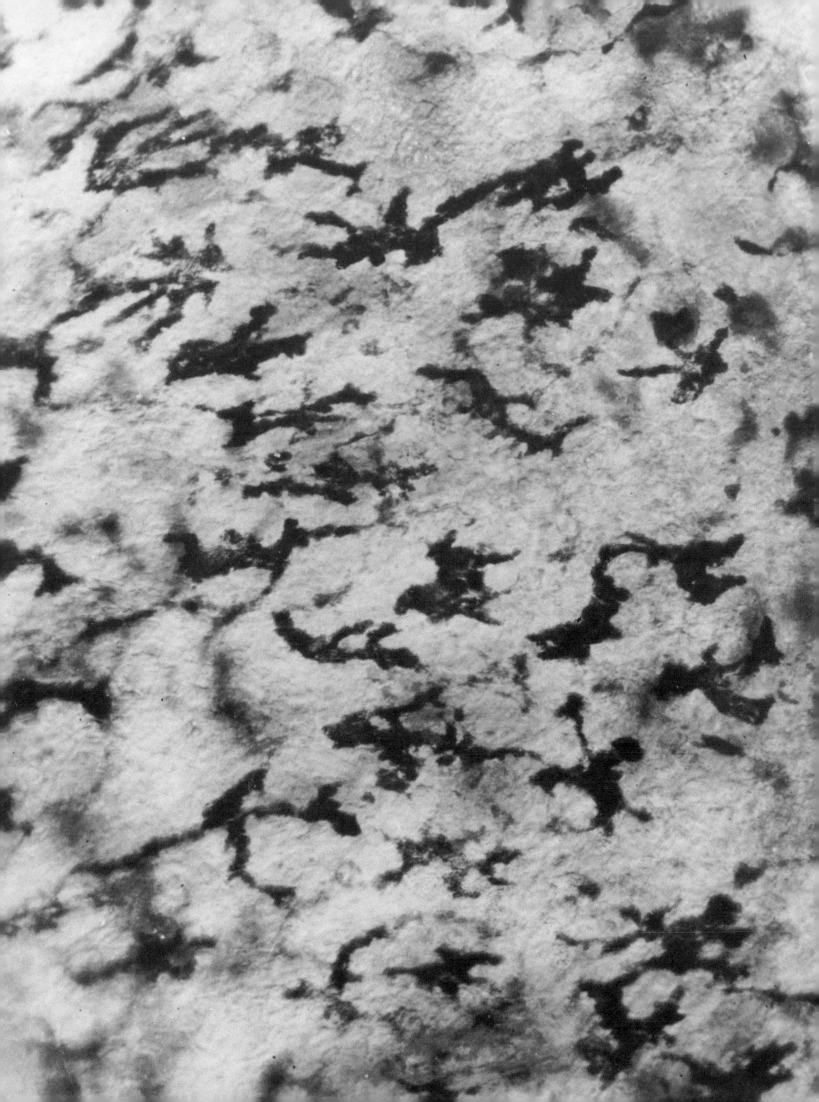

Sea of Joy

Marie Jager

For over sixty years, Jean Painlevé (1902–1989) made more than 200 short films, documenting marine animals such as octopuses, sea urchins and shrimps, as well as species with poetic names like halammohydras, eleutherias or obelarias. Painlevé possessed a remarkable talent for showing marine life in ways that had never been seen before, but also revealed himself, in the process, to be a brilliant technical innovator, customising equipment according to specific needs. The return of film as a contemporary art form combined with a renewed interest in him by younger generations of artists encourages us to look again closely at the work of Jean Painlevé.

Jean Painlevé in his Montparnasse studio, c. 1931

Central to the development and maturation of his work was his relationship with the region of Finistère in Brittany. Painlevé, who grew up in Paris, spent his childhood summers in Le Pouldu, on the Southern coast of Brittany. There, he was nicknamed by his cousin, Pierre Naville (who would become André Breton's right arm in later years), the "Pêcheur de Triton" ("The Newt Fisherman"). Also fortuitous for the development of his work, Painlevé met, during his studies, his lifelong companion and future collaborator, Geneviève Hamon, whose family home was located in Port Blanc on the Northern coast of Brittany. Painlevé installed his first studio in the Hamons' house, in the early 1920s, to develop his prints and shoot film, and would invite the creative community with which he surrounded himself to stay in Port Blanc.

Painlevé's close friendships with painters, sculptors, composers and filmmakers, were also formative for his work. His conversations with his peers, including Luis Buñuel, Fernand Léger, Alexander Calder, Edgar Varèse and Jean Vigo, as well as the privileged connections they afforded him to new developments in the arts, propelled his practice at a young age. While still in his early twenties, Painlevé published an essay in the first issue of the journal *Surrealisme*. In the following years, his photographs were featured in vanguard magazines such as George Bataille's *Documents*, Carlo Rim's *Jazz* or Henri Barbusse's *Monde*. His first films were championed by the burgeoning new art scene that included the Galerie de la Pléiade, where he held his first exhibition, Germaine Dulac's cine-club circuit or movie theatres such as the Studio 28 or Les Miracles.

At the same time, in his artistic concerns, Painlevé operated in a world apart from his peers. If there was a shared belief in modern cinema as an art form as well as a social practice, in Painlevé's hands, film never became completely abstract and expressive as in the Bauhaus trend, exemplified by László Moholy-Nagy's films, nor based on objective chance as in Surrealist and experimental cinema. Painlevé also did not use the photographic medium as a detached tool to create systematic typologies, as was popular with the artists of the New Vision and Karl Blossfeldt's *Urformen der Kunst*. Evident in his writings and work, Painlevé was passionate about the camera's descriptive power, pushing the medium to its limits through extreme micro and macro photography. Painlevé's principal motivation was the pleasure he derived from creating these two-dimensional, infinitely detailed and large-scale works out of tiny sea creatures normally considered unworthy of attention. His concern was also being able to share his work with the widest audience possible, and photography and film, with their unique capacity for reproduction, were ideal vehicles for that.

Opposite:
Chromatophores, 1931

Technologic

Painlevé's films stand out because of his profound interest and creative use of available technologies (superior optics, faster film or more mobile cameras), rather than because of exceptional, exotic and rare species from distant shores as in wildlife cinema.

The animals Painlevé chose to film were easily found in the shallow waters of the Atlantic Ocean. The lobster, shrimp, crab, sea urchin, squid or scallop were all an everyday sight and meal for the local population of Brittany. Painlevé collected those on the beaches of Perros Guirec, Treguier, Port Blanc, Roscoff, Le Pouldu — a very limited geographic perimeter.

Painlevé rarely shot on location but in a studio. If in 1933, he was able to secure a waterproof case for his camera and captain Le Prieur's revolutionary first autonomous "scuba", Painlevé was never satisfied with the images he made while diving, because they did not match the precision of the ones he made in a controlled environment.

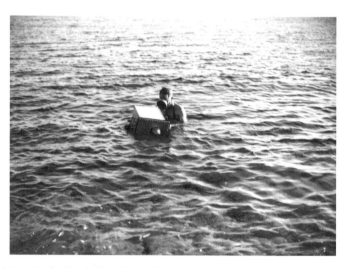

Jean Painlevé in the bay of Arcachon, c. 1933

The descriptions in the press[1] of Painlevé's studio in the cellar of a building in Montparnasse give us a sense of the type of environment the films were made in: white walls covered with buttons, switches, levers, meters; a clutter of cameras, lenses, microscopes, projectors, files, specimens, glassware of all shapes and sizes, aquariums filled with seawater, ambient lights and spots; wires running across the space in all directions … In one article, Painlevé mentions that most of his shooting equipment was recycled from old equipment, such as a camera partially made with the mechanism of a clock bought at a discount store, allowing the automatic activation of the shutter and light.

In his notes and articles, Painlevé not only systematically mentions the specific cameras he used throughout his life (from the photographic camera he made in 1912 with the bottom of a bottle, to the 1950s Cameflex and its custom-made shoulder harness). He also repeatedly pays tribute to the legacy of Etienne-Jules Marey's shooting gun and Jean Comandon's micro-cinema, pioneers who inspired him to explore film speed and high-speed cameras and associate the microscope to his camera.

The technical and practical complexities involved in Painlevé's everyday work also shed light on the role of the aquarium, which we are constantly made aware of, but that we never see. The result of filming through the glass of an aquarium, aside from the crystalline luminosity of the image, is that the pictures become highly staged ones. Not only are the animals cut off from their original context, from their natural environment, but Painlevé's aquarium is often a neutral background, the décor reduced to a minimum. Natural elements, such as rocks or seaweeds, are often placed for functional purposes, so as to show an animal's unique anatomical aspect, the seahorse's prehensile tail or the role of suckers in the locomotion of sea urchins. Pierre Huyghe's aquarium piece, *Zoodram 4–5*, recalls a scene in Painlevé's 1928 film *The Hermit Crab*, in which a hermit crab tries to curl into and carry a perfectly shaped glass tube, comically underlining the incompatibility between the organic shape of the hermit's tail and the modern, smooth object.

Opposite:
Jean Painlevé's studio
in Roscoff, c. 1950

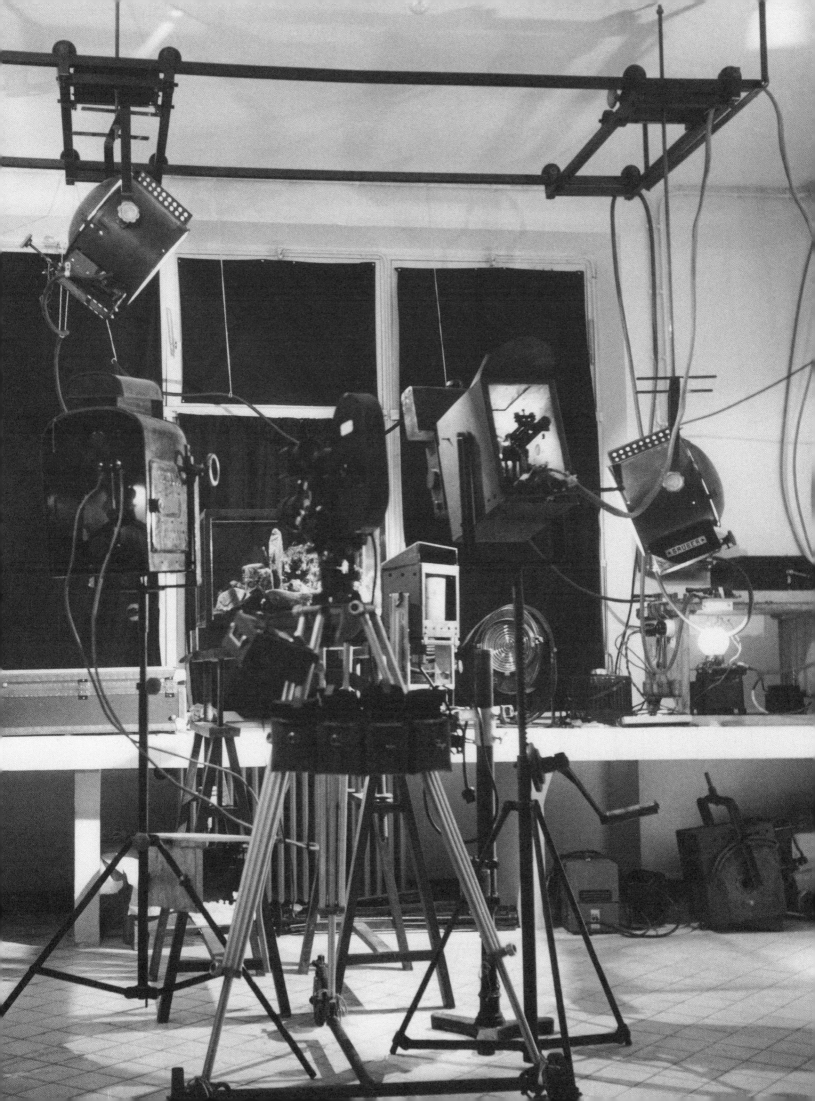

Lobsters Quadrille

The lack of context, and of pictorial, stylised 'natural' background, allows Painlevé's camera to reveal the formal qualities of the subjects themselves. Whether it is the seahorses softly floating in a monochrome of grey or the sea snails in *Acera* swimming across a dark background, the presentation is formally identical with the way, for instance, Painlevé filmed Alexander Calder's first mobiles around 1930, shapes gently moving against a white backdrop.

The spectacle of choreographed movement (and the pleasure it gives us, as attested by the mobiles hanging above cribs) is Painlevé's principal alphabet. It is no coincidence that dance often appears in his filmography, with shorts on classical ballet or folkloric dances, explicit reference to ballet in some titles (*Sea Ballerinas* or *Acera or the Witches' Dance*) or in the commentaries. When Painlevé's *Skeleton Shrimps and Sea Spiders* was screened in 1930, Fernand Léger called the film "the most beautiful ballet he had ever seen".[4]

Acera or the Witches' Dance, 1978

Painlevé also had a lifelong interest in music, whether it was through his love of early jazz or friendship with composers such as futurist Luigi Russolo, author of the manifesto *The Art of Noises* or, Edgar Varèse. Painlevé's first films were silent, and he preferred to screen those in their silent original versions, even after he had collaborated with movie studios to add soundtracks for mainstream distribution. But music gradually became an integral part of the work, especially following his 1945 film *The Vampire*, with its collage of early jazz, borrowed footage from Murnau's *Nosferatu* and documentary images of a Brazilian bat. "Vertical montage", Eisenstein's theory on the synchronisation of music and image, is systematic in Painlevé's post-war films, whether it is the juxtaposition of the flabby octopus and Pierre Henry's electronic sounds or of François de Roubaix soundtrack and the transition of liquid crystals seen through the microscope.

A trance-like state, induced by music and repetitive, synchronised movements, is even perceptible in the 1978 film *Acera*. In an unusually long sequence, the music of Pierre Jansen rises and falls in tandem with the movements of the photogenic sea snails, opening and closing their cloak in an incredibly graceful but repetitive way, with no clear ending nor intention in sight. Their dancing and flying across the screen in perfect synchronisation to the beats and rhythm of the soundtrack recall the teenage dancers in Mark Leckey's *Fiorucci Made me Hardcore*, the shakers in Dan Graham's *Rock my Religion* or Jean Rouch's documenting with a single take the dancing to the beats of the ancient drums of Niger in *Tourou and Bitti*.

Opposite:
The Seahorse, 1931

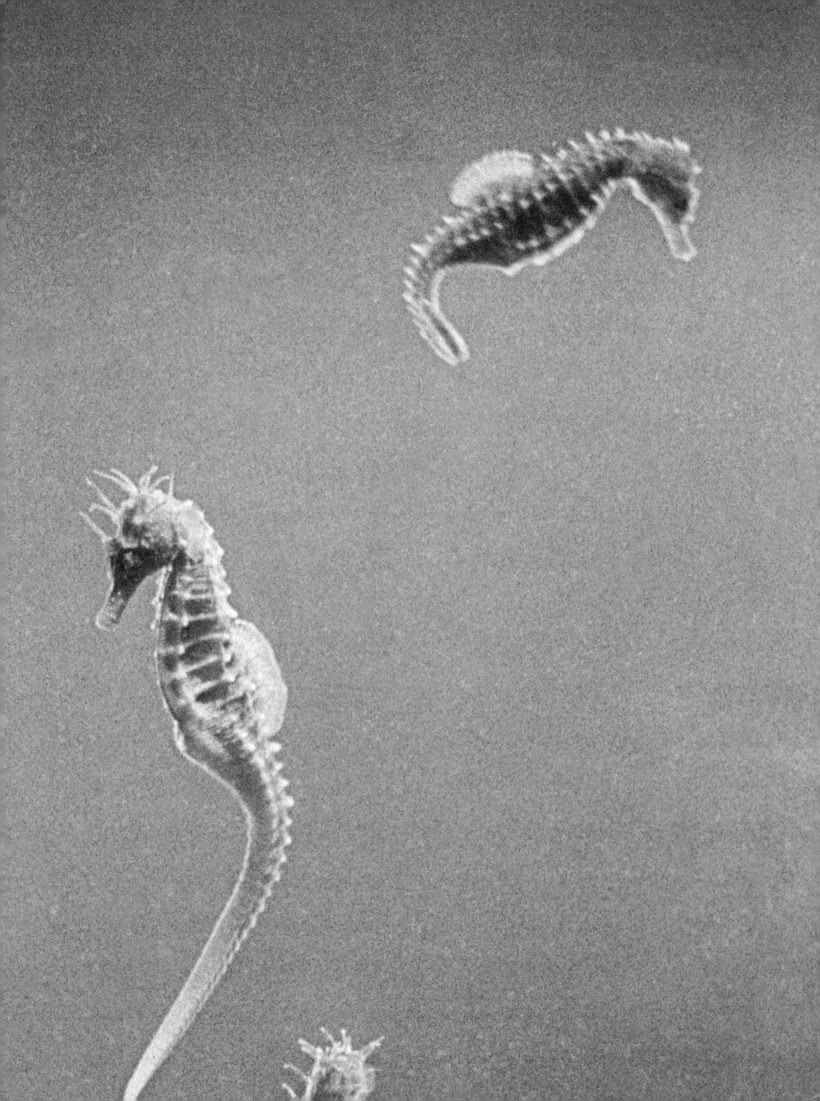

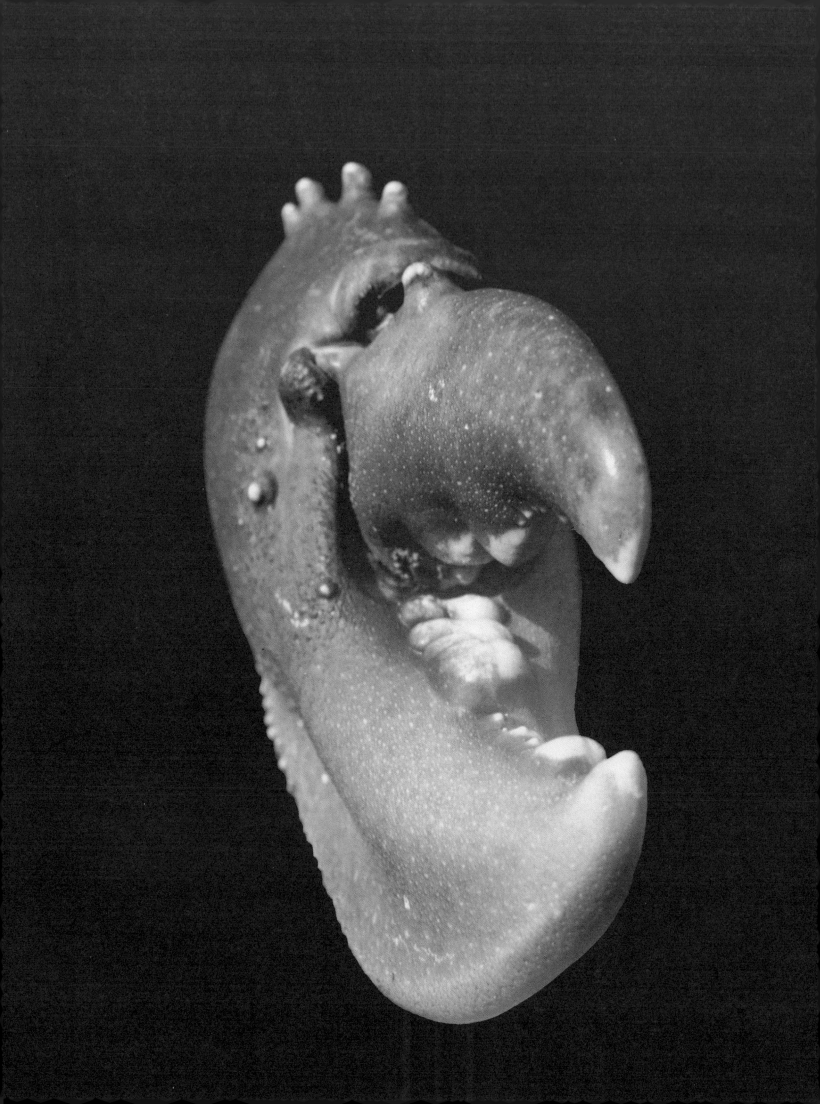

Cauchemar de Homard

In the 1970s, George Balanchine visited Painlevé in his studio in Paris where he saw Painlevé's 1975 film comparing European and American lobster species. Shortly after the visit, and following a life-long obsession with the animal, Balanchine started writing a new choreography, 'Lobster Dreams', entirely based on the movements he had seen in Painlevé's film.[5] This fascination with lobsters was also shared by the surrealists: Gerard de Nerval's famous pet lobster appears in the essay entitled 'Crustaceans' which accompanied Painlevé's photographs in the issue number 6 of the journal *Documents*, Dali's famous 1936 *Lobster Telephone* or Joseph Cornell's 1949 *Zizi Jeanmaire Lobster Ballet* box.

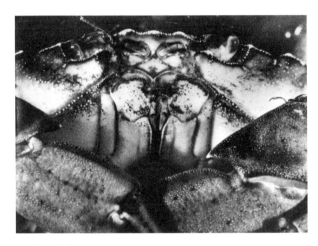

Crabs and Shrimps, 1929

Painlevé never wished to be pigeonholed as a surrealist and refused to commit to any of the many rival factions of artists of the early 1930s Paris (while still associating and exhibiting with members of the various schools, such as Man Ray, Brassaï, Kertész and others). In fact, he resisted any type of confinement. He deplored, for instance, that only a few specialists, behind the closed doors of the laboratory, practised biology. However, Painlevé's work was not created in an aesthetic vacuum, but within a specific framework, which was part of his formative milieu. Painlevé's recognisable style is evident in one of his most famous photograph, *Lobster Claw*.

Here, Painlevé presents a three-quarter view of a single claw, the tip of the claw pointing towards the viewer. The rest of the animal's body has been cut-out from the picture, which has a seamless, black background. There are also no references to any unit of measurement showing size or scale. As evidenced in the few installation shots of Painlevé's exhibitions and original prints, he produced very large-scale prints, blowing up, as if looking through a high-powered magnifying glass, minuscule animals or microcosmic views.

As a result of the claw's isolation, the image emphasises the striking visual power and presence of the subject. Painlevé's camera meticulously describes every detail, bump or texture of the surface with an extraordinary accuracy and revelation. Everything that is contained within the frame clarifies, explicates the subject in a concrete, material way.

Painlevé's frequent use of extreme close-ups and microphotography underline the transformative power of photography. For instance, there is very little empty space around the lobster claw, which is tightly framed in the vertical format used for portraits. This spatial compression allows for a transformation to take place, the claw resembling a grinning face. It is no coincidence that after the war, Painlevé renamed his photograph *Lobster Claw or De Gaulle*, after realising the uncanny resemblance with the iconic French political figure. The photograph also recalls modernist photography of ethnographic artefacts, for example in the way Walker Evans chose to photograph African sculpture. A print of *Lobster Claw* was, not surprisingly, kept side by side with a photograph of an ethnographic mask, both formally identical, in the collection of a Belgian situationist.

Metamorphosis regularly occurs in Painlevé's work. Painlevé had a profound admiration for Alexander Calder, who on his frequent stays at the Hamons' house in Brittany, would transform any piece of metal around him, including a fork, into something else, a beautiful cuff bracelet.[6]

In Painlevé's playful exploration of title sequences, words transform into other words: 'Faim' into 'Fin' (Hunger and The End). The live organisms in the films are also, on several occasions, shape shifters. The seaweeds, in *Shrimp Stories*, gradually, with every coming wave, rearrange themselves on the sand to form the words 'The End', as do the seahorses, sea urchins and diatoms. Some of these animals also signify change, whether it is the male seahorse's transformation through pregnancy into a big bellied, eye rolling, anxious genitor victim of contractions, or the acera mollusc, which changes sexual identity and orientation according to its position in the sex chains they create. In the photograph *Woman with a Renaissance Ruff or Swimming Acera*, which is constructed like a card game, the same image of the mollusc is labelled either as a Renaissance lady or as a swimming acera, depending on the direction the print is hung. Painlevé filmed a few plastic surgery operations in the early 1930s, when the practice was still in its infancy, and wrote on this a tongue-in-cheek article for the journal *Le Phare de Neuilly*. To illustrate his article, Painlevé chose among his photographs of surgeries a Warhol-like diptych of the same woman in profile, "before" and "after" her nose operation.[7]

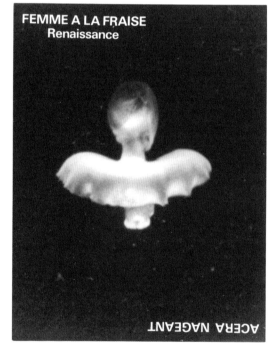

Woman with Renaissance Ruff or Swimming Acera, 1972

In *Phase Transitions in Liquid Crystals*, an abstract colour film from the late 1970s, Painlevé documents with a high-speed camera connected to a polarising microscope, the transitory nature of the material (in between solid and liquid state). Liquid crystals dramatically change colour and shapes according to the light, temperature or pressure of the environment. This work echoes the slide projection installation by Gustav Metzger, *Liquid Crystal Environment*, and more generally the immersive cinema of the late 1960s and 1970s. The film also brings to mind issues of formlessness, the state of indeterminacy of shape or colour, a topic which has been much explored in Mike Kelly's works *Garbage Drawings* or *Framed and Frame*, with its diptych photographs of a coral landscape shot in the Belle Isle Aquarium in Detroit. As Michael Cary underlines in his article 'Tentacle Erotica', there is an ambiguous eroticism in the amorphous forms of Painlevé's 1920s films, which he notes influenced Picasso's abstracted, mollusc-like portraits of Marie-Thérèse Walter.[8] The ever-changing colours, shapes and contours of the liquid crystals carry as well a sense of confusion and eroticism.

Painlevé's use of micro-cinematography in his first film, a 1927 study of protoplasmatic movements in the stickleback's egg, also, like the liquid crystals, brings the aesthetic of painterly biomorphic abstraction to film. While the title card announces the contractions of the protoplasm, the foetal-like primary matter, we see elastic and transparent hemispheric forms, furrows, discs and circles. Eisenstein, in his writings on Walt Disney's animated characters, came up with the theory of the "plasmatic" quality, the infinite ability to shape and alter one's form, based on the protoplasm.[9] Given his close friendship with Painlevé, it is probable that Eisenstein had seen his early protoplasm films. Eisenstein believed that Disney's boneless creatures (particularly in the early days of animation, such as in the *Silly Symphonies*) allowed the average viewer to temporarily liberate herself/himself from the tedious nature and rigid structure of modern life. The "rejection of the once-and-forever allotted form" demonstrated how a more liberated life could be achieved.[10]

The Ignorant Schoolmaster

There would not have been a New Wave without Jean Painlevé and his unsinkable camera.

Jean-Luc Godard [11]

My dear Marie zotto, don't forget to tell your mother to take you to see the Chinese [dancers] at the Olympia! This will allow you to try to imitate them on your way back home.

Jean Painlevé [12]

In an article entitled 'How we unlearn through cinema', Painlevé speaks out against the commonplace notion that at least, in documentary cinema, as opposed to popular movies, we "learn something". Painlevé mentions "Learning … an infamous word which has already corrupted the way 90% of mankind thinks."[13]

Jean Painlevé on the set of *The Pigeons in the Square*, 1982

This might seem contradictory in view of Painlevé's well known militancy for film as a social practice and educational cinema. Painlevé presented *Freshwater Assassins*, his film on aquatic insects in the ponds outside of Paris, as a 'gangster film', a film noir. In a surprising turn, the film won the prize for best film for school audiences at the Brussels International Film festival in 1947.

In fact, like Jacques Rancière's "ignorant schoolmaster",[14] Painlevé was encouraging his readers (and more generally his audience) to unlearn the "often naïve and false" lessons we inherit from teachers and parents, and return to learning through observation. This experimental notion of knowledge is also part of the subject of Claude Lévy-Strauss's *The Savage Mind*.

Painlevé's rejection, throughout his life, of traditional education models and values would serve him in the late 60s, when he was appointed Professor at the Vincennes University. Hélène Cixious and small group of militants, in response to the student movement of 1968, created this "Experimental University of Vincennes" in 1969. The radical university, located in the woods of Vincennes thirty minutes East of Paris, became notorious for its famous faculty and founding members (Gilles Deleuze, Michel Foucault, Jacques Lacan and many others) and its "popular" nature: there were no requirements to be able to enrol (many factory workers or housewives became students there) and the hierarchies between professors and students was abolished. The institution and its building were completely torn down a few years later by the government following the highly contentious nature of the project. While he was teaching there, Painlevé exposed his students to the technical aspects of filmmaking and devised series of exercises for the synchronisation of images and music. It is around that time that Painlevé made *Diatoms*, a film in which he shares the voiceover, for the first and only time, with a young German student named Carola Meierrose. In this work, his complete lack of knowledge on the subject of diatoms is Painlevé's frequent reply to Meierrose's comments on what is seen in the images.

But it is probably in his last film, the *Pigeons of the Square*, that Painlevé's views on education are the most explicit. In the opening credits, Painlevé announces that the goal of his film is to interest "young people" in the "method of testimony". As described by Painlevé, this method implies "observation" and "the way in which the information is shared". It is the *manner* in which the "young people" will report what they have observed that is important. A quite comical scene in the film encapsulates what has been announced earlier on. Painlevé, who is in his eighties, sits on the rooftop in what looks like the Brutalist concrete landscape of the 13th district of Paris, surrounded by children. Two young girls are in charge of imitating for the group the complex way pigeons walk. We observe the girls walking in a straight line, side by side, arms along the body, with a dedication and seriousness in their efforts to simultaneously pan and tilt their torso, extending and retracting their neck in coordination with their steps.

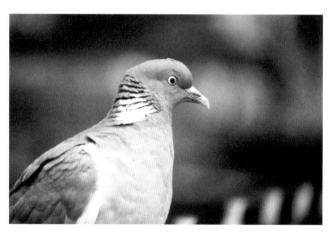

The Pigeons in the Square, 1982

Painlevé's views on teaching, as well as the strict documentary style he promoted throughout his work, were non-assertive in nature. This non-assertiveness probably explains that there have been few formal studies of the work and that the films have mostly been talked about through the animals being portrayed. But Painlevé's emphasis on mimicry, re-enactments of all kinds, demonstrate that his goal was not the transmission of knowledge, what we can read in biology books, but the transmission of creativity itself, which can develop in any discipline or through any medium (Painlevé even developed a line of jewellery), and to pass down its contagious nature to future generations.

Notes

1
Leo Sauvage, 'The Institute in the Cellar', *Regards*, 10 May 1935.

2
Lewis Carroll, 'Lobster Quadrille', *Alice's Adventures in Wonderland*.

3
Jonathan Cott, *Visions and Voices*, Knopf Doubleday, New York, 1995.

4
'Miracles', *L'intransigeant*, 23 December 1930. Also attending the screening, Picasso, Henri Laurens or Jacques Lipchitz reported to the press the "great poetic power", "a surprising opening on reality" or an "unequalled plastic richness".

5
Giselle Leichtentritt, 'Unbekannte Choreografie von George Balanchine entdeckt', *Ballettanz*, October 2003.

6
Brigitte Berg, 'Contradictory Forces', *Science is Fiction*, MIT Press, Cambridge MA., 2000.

7
Jean Painlevé, 'Autour du bistouri rédempteur', *Le Phare de Neuilly*, no. 1, 1933.

8
Michael Cary, 'Picasso and Painlevé', *Art in America*, September 2011.

9
Sergei Eisenstein, *Eisenstein on Disney*, Methuen, London, 1989.

10
David Bordwell, *The Cinema of Eisenstein*, Harvard University Press, Cambridge MA., 1993.

11
Hélène Hazéra,. 'Science et Fiction', *Libération*, 4 July 1989.

12
Jean Painlevé, postcard dated 17 May 1984, addressed to Bloody Mary Geiger.

13
Jean Painlevé, 'Comment on désapprend par le cinéma', *Le Point*, March 1936.

14
Jacques Rancière, *The Ignorant Schoolmaster*, Stanford University Press, Stanford, 1991.

List of works

All works copyright and courtesy
Archives Jean Painlevé, Paris

Films

L'Hippocampe (The Seahorse), 1934
35mm film transferred to digital
Black and white, 14 min.
Music by Darius Milhaud

*Le Grand Cirque Calder 1927
(Calder's 1927 Great Circus)*, 1955
16mm film transferred to HD
Colour, sound, 43 min.

Les Oursins (Sea Urchins), 1958
35mm film transferred to digital
Colour, 11 min.
Organised noise by Jean Painlevé
in homage to Edgar Varèse

*Transition de Phase dans les
Cristaux Liquides (Phase Transition
in Liquid Crystals)*, 1978
16mm film transferred to HD
Colour, 6 min.
Music by François de Roubaix

Wall covering

Digital print wallpaper created from:
jHp Seahorse Motif n° 7, 1936
Designed by Geneviève Hamon
Gouache on paper, 49 × 64 cm

Photographs

Pieuvre (Octopus), 1927
Gelatin silver print
68 × 81 cm

*Ventouses de la pieuvre
(Suction Cups of the Octopus)*, 1927
Gelatin silver print
82.6 × 104.6 cm

Pince de homard (Lobster Claw), 1929
Gelatin silver print
87 × 70 cm

*Devant la tête de la crevette
(In Front of the Head of the Shrimp)*, 1929
68 × 81 cm

*Pale très grossie d'une queue de crevette
(Shrimp Tail Greatly Enlarged)*, 1929
Gelatin silver print
40 × 50 cm

*(Rostre sur le nez de la crevette)
Rostrum on the Nose of the Shrimp*, 1929
Gelatin silver print
30 × 40 cm

Pince de crevette (Shrimp Claw), 1929
Gelatin silver print
40 × 50 cm

Pince de crabe (Crab Claw), 1930
Gelatin silver print
81 × 68 cm

*Corne de l'hippocampe
(Horn of the Seahorse)*, 1931
Gelatin silver print
74.6 × 62.6 cm

Postcards

Advertising postcard for jHp jewellery
(model 1), c. 1936
Gelatin silver print
9 × 14 cm

Advertising postcard for jHp jewellery
(model 2), c. 1936
Gelatin silver print
9 × 14 cm

Advertising postcard for jHp jewellery
(model 3), c. 1936
Gelatin silver print
9 × 14 cm

Jewellery

jHp necklace, c. 1936
Silver

jHp earrings, c. 1936
Gilded brass and Bakelite

jHp bracelet, c. 1936
Gilded brass and Bakelite

jHp bracelet, c. 1936
Gilded brass and Bakelite

jHp bracelet cuff, c. 1936
Gilded brass and Bakelite

jHp bracelet cuff, c. 1936
Gilded brass and Bakelite

jHp bracelet cuff, c. 1936
Gilded brass and Bakelite

jHp bracelet cuff, c. 1936
Gilded brass and Bakelite

jHp bracelet cuff, c. 1936
Gilded brass and Bakelite

jHp bracelet cuff, c. 1936
Gilded brass and Bakelite

jHp bracelet cuff, c. 1936
Gilded brass and Bakelite

jHp brooch, c. 1936
Gilded brass and Bakelite

jHp brooch, c. 1936
Gilded brass and Bakelite

jHp brooch, c. 1936
Gilded brass and Bakelite

Jean Painlevé
15 March – 4 June 2017

Curated by Jonathan Watkins and Marie Jager
Assisted by Roma Piotrowska and Oliver McCall

Ikon Gallery
1 Oozells Square
Brindleyplace
Birmingham B1 2HS, UK

Ikon is supported using public funding by Arts Council England
and Birmingham City Council

www.ikon-gallery.org

Edited by Jonathan Watkins and Marie Jager
Texts by Marie Jager and Jean Painlevé

Photography by Jean Painlevé, except:
Philippe Halsman, p. 20; Stuart Whipps, pp. 21, 23, 24

Designed by James Langdon
Printed by Emmerson Press

Forms and Movements in the Documentary by Jean Painlevé
translated from French to English by Karine Leroux

ISBN: 978-1-911155-08-9
Distributed by Cornerhouse Publications
HOME, 2 Tony Wilson Place, Manchester M15 4FN, UK
Tel. +44 (0) 161 212 3466 and +44 (0) 161 212 3468
Email: publications@cornerhouse.org

Ikon Gallery Limited trading as Ikon
Registered charity no: 528892

ARCHIVES JEAN PAINLEVÉ

ARTS COUNCIL ENGLAND

Birmingham City Council

Front cover image:
Two Male Seahorses, 1931

Back cover image:
Galathea Claw, 1928